SANDRA
EIGHT

Los Angeles
Pictures
2003

Los Angeles

Pictures

R.B. Kitaj

21 May – 5 July, 2003

LA Louver Publications · Venice, California

L | A | LOUVER

Foreword © 2003 Peter Goulds
Essay © 2003 R.B. Kitaj

ISBN 0-9708187-0-x

This exhibition has been made possible with the cooperation
of Marlborough Gallery, London and New York.

CONTENTS

FOREWORD

During 1976 the Hayward Gallery in London presented an exhibition of drawings entitled *The Human Clay*, curated by R. B. Kitaj. This show celebrated the work of forty-eight artists, all of whom were living and working in London. With this exhibition Kitaj lay claim to the existence of a 'School of London'. For this and many other reasons, *The Human Clay* became a significant moment in the recognition of the importance of British figurative traditions to the art history of the latter half of the twentieth century. Certainly the work of the vast majority of the artists included was little known beyond the circle of artists itself. It was an inspired exhibition, and one that led to my first meeting with R. B. Kitaj, in 1979.

Influenced by my experience at the Hayward, I set about to organize a gallery exhibition for L.A. Louver. Kitaj subsequently not only contributed a group of five extraordinary pastel drawings, but also generously edited his essay from *The Human Clay*, and contributed this text to the catalogue of the exhibition, which I entitled *This Knot of Life*. The L. A. Louver exhibition also included paintings and drawings by William Coldstream, Lucian Freud, Peter Blake, Euan Uglow, Francis Bacon, Howard Hodgkin, Leon Kossoff, Frank Auerbach, and David Hockney. It was David who introduced me to Kitaj, and through their participation made the seemingly impossible politics of my exhibition proposal, a possibility to overcome. To this day I regret that I was unable to include the work of Michael Andrews, other than as a reference point in the catalogue that acknowledged his artistic importance.

Since that time, many exhibitions, essays, and discussions have taken place all over the world, in consideration of the viability of this topic. This is now thankfully behind us as many of the artists have gone on to be appreciated for their unique contributions. However, *This Knot of Life* heralded the commencement of a number of my most cherished professional associations, and personal friendships. For example, since 1979 I have represented David Hockney and Leon Kossoff, which in turn has led to many involvements in gallery and museum exhibitions, on several continents. It has also been possible to maintain a professional engagement with the work of Frank Auerbach. Throughout this time I have regularly visited Kitaj's studio, both in London and now in Los Angeles. I cannot adequately describe how important all of these privileged associations have been to my personal and professional life, and what this dialogue represents to an Englishman, from London, who first attended art school in 1965.

Los Angeles Pictures

The circumstances that have led to *R.B. Kitaj: Los Angeles Pictures* are very well described by Kitaj in this catalogue, and by others elsewhere. However, it is with great pleasure, accompanied by gratitude and a sense of pride that I thank R. B. Kitaj for allowing L.A. Louver to present his first gallery exhibition in Los Angeles. The works contained in this show represent a celebration of life, and the accomplishments of an artist in his prime, who has been working for the past six years at the top of his game. Los Angeles, the city of Angels, and L.A. Louver Gallery are the beneficiaries of this contribution by one of its recent residents.

While preparing *This Knot of Life* I also made my initial contact with many individuals from museum, critical and business areas of the art world, with whom I have maintained on-going professional associations, and long standing friendships. On this occasion I would like to thank Geoffrey Parton of Marlborough Fine Art in London, for his encouragement and support, not only towards this exhibition, but for many other conversations and involvements over the years. It would not have been possible to arrange this show without the co-operation and assistance of Pierre Levai, Tara Reddi and Gilbert Lloyd of Marlborough Gallery, to whom I offer my appreciation.

I would also especially like to thank all of my colleagues at L.A. Louver for their devotion and commitment to the gallery, and to this undertaking. In preparing this catalogue and exhibition I would like to recognize the particular work of our archivist Liz Fischbach. I also thank our managing director Elizabeth East for her work as press liaison; the photographers Paul O'Connor and Robert Wedemeyer, and our graphic designers Sean Adams and Noreen Morioka. We all unite to celebrate Kitaj's assistant Tracy Bartley, and my co-director Kimberly Davis without whom very few decisions are made at L.A. Louver.

Peter Goulds
2nd April, 2003

LOS ANGELES

I moved back home to L.A. seven years ago. Though I was born in Cleveland
and lived mostly abroad, L.A. became my hometown over the years. Both my
parents died here; My grown kids settled here; My three grandsons were born
here; I had pals in L.A. from grade school, high school and college; Above all
I met Sandra Fisher here in 1970 when I taught at UCLA. When she died in
London, 25 yrs later, London also died for me, so I came home with our boy,
Max, to live happily ever after among six Kitaj boys in Westwood. Also, I
found a strange, romantic new subject out here. Sandra and me. Last year, I
had a show, at the National Gallery in London, of some of my pictures based
on master paintings, called *Kitaj In The Aura Of Cézanne And Other Masters.* My
3 favorite paintings are Cézanne's last three grand Bathers, one of which is in
the National Gallery itself. They put it right smack in the middle of my show. I
had begun some paintings in L.A. about my great romance with Sandra. These
paintings were influenced by Cézanne's Bathers, which had driven Picasso
and Matisse nuts a hundred years ago. They
were both doing crucial Bather pictures in
1906 as Cézanne died. Picasso's revolutionary
Demoiselles are Bathers. Almost 50 years later,
Matisse was cutting out blue paper Bathers when
I was a young artist in the 1950s. Bathers, as a
subject didn't interest me, but Lovers did.

Sandra and I became Lovers again, after her death, in my old
age in Los Angeles, The Angels. I could make love to my angel
with my paintbrush, fondle her again, caress her contours. This
greatest story ever told, the Woman-Man Story, has become
quite rare in painting since the death of Picasso. Earlier, many
painters had shown the woman and man in a love situation – such
as Picasso, Munch, Schiele, Chagall, even Matisse, as in his great
Conversation. But very few in recent years. Of course, many of
the best painters of the last few decades have been gay and a lot
have been abstract, and many of the best heterosexual painters
have done only single figures, like Giacometti, Auerbach, Kossoff
and most of Freud. My Sandra was an exception. She often
painted nude men and women embracing. Her example has been
a major influence on me. So, I've done about 20 of these love
stories so far, and our romance need not die. Nietzsche called
tragedy "the supreme art in the affirmation of life". Jewish
Angelology, Kabbala, Talmud and medieval philosophers believe
in angels.

MY JEWISH ART

Jewish Art is what I like to call my own art for many reasons which excite me. It is what I'd like to do with my life, what's left of my life. An adventure. Some people loathe the term Jewish Art for many reasons. Some don't mind the term. Jewish Art is, for me, what Foucault would call a limit-experience, an ecstasy in danger, a Temptation To Exist. Like a lot of things, it's a highly personal affair. It will never satisfy anyone but it gives me some heartfelt pleasure. I'm not aware of any other painter who wants to do a Jewish Art, but maybe such painters will happen, maybe not. I am the primitive of the Jewish way I've discovered. This kind of painting that I try to 'realize' (Cézanne's famous word) is driven by my fascination with the Jewish Question and its Jews who have been in trouble for 5000 years. I remain inexpert in normative Judaism, but very interested by it. I study it a lot on my own in an irregular way. I feel that a painting can become deserving of being called Jewish Art as my aspirations for the painting spell out Jewish ambitions, conditions and predicaments. For instance, my own Jewish American histories and predilections. What I have called Diasporism is a subtext for my Jewish Art because I don't live in the besieged Jewish State, like Herzl I have no Hebrew and I am a flawed but excited auto-didact in Jewish studies. I hope and believe that my strange Jewishness rehearses its essence in my pictures, but I'm very anxious about the rehearsal. A great deal of art, especially today, is art because the artist and protagonists say it is, because that's what one wants to do with one's life.

Clement Greenberg wrote:
"I believe that a quality of Jewishness is present in every word I write, as it is in almost every word of every other contemporary American Jewish writer."

That is the way I feel about my pictures.

R.B. Kitaj

Since my Jewish Art is still primitive in its way, one mustn't expect to identify a style as one does in Egyptian Dynastic or Japanese Art, or such art of circumscribed periods. Jewish Art will be Cosmopolitan, as for instance, Surrealism (which can include some Picasso) has been. Another Cosmopolitan Art has been the Abstract-Expressionism of the School of New York. Half its leading painters were Jews—Rothko, Newman, Guston, Gottlieb, and the other half – Pollock, Motherwell, de Kooning, Avery were married to Jews. I daresay the vast majority of their critical protagonists, historians, dealers, collectors and curators have been Jews. Can that School (A-E) be called a prologue to a Jewish Art?

Clement Greenberg wrote:
"Kafka wins through to an intuition of the Jewish condition in the Diaspora so vivid as to convert the expression of itself into an integral part of itself; so complete, that is, that the intuition becomes Jewish in style as well as in sense... the only example I know of an integrally Jewish literary art that is fully at home in a modern Gentile language."

Unattainable for me?? Too high? I wonder.

Let me put a simple case: A controversial Jewish painter, a dissident, enamored like myself, by a yearning for a Jewish Art (for whatever mad Jewish reasons), paints a picture of and about two Jews, the painter and his wife, say, having been wed in an ancient Sephardic Orthodox synagogue, (a minyan under the chupa). The painter paints that wedding, which took place, not in Israel, but in the Jewish Diaspora, Israel's powerful Counterlife. The painting's "style" has been influenced by the work of both Jewish and Diasporic (Host) Art. What is called the artworld seems to me to be half-Jewish, so the picture may or may not have a Jewish destiny. Thus, that painting enters what the Jewish philosopher Derrida (writing about Freud) calls 'Archive Fever', or what the Jewish art historian Aby Warburg called the 'Social Memory', at the very least in this painter's (my) head. Furthermore, this painter conjoins a brief free-verse commentary to his pictures within the ancient Jewish tradition of exegetical argument. This last factor, among other reasons, breeds some hatred, I daresay Jew-hate, in some right-thinking people who guard the art Castle. The preceding example does not indicate that my picture has been 'realized' (Cézanne again), only that I have been as true to myself as I can, even true to a strangeness that remains unfinished. But history will tell.

For me, a Jew is a person of some Jewish descent or intent. For me, he or she can be a freethinker, a dissident or even a Christian, etc., as well as a Jew (Mendelssohn, Mahler, Heine, Schönberg, Balthus, Wittgenstein et al). Also, a picture can be more or less intentionally Jewish for me, such as these new Los Angeles paintings of mine – pictures of two Jewish Angels, painted by a Jew in the 3rd largest Jewish community in the world, (after New York and Tel Aviv), and endowed with many Jewish attributes, proclivities and sources, Diasporic (Host) Art notwithstanding. As to Jewish formal, or stylistic value, I'm still studying that Jewish Question. It may be a Promised Land.

R. B. Kitaj, Los Angeles

Inspired by the loving faces of Christ's Jewish grandparents, Joachim and Anna, in Giotto's Scrovegni fresco at Padua. I detected Barnett Newman's Zip in the line running between the profiles, so I emphasized it in the profiles of Sandra and me.

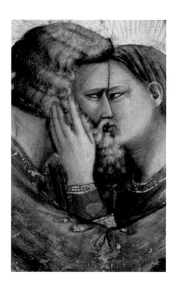

Barnett Newman (1905-1970)
First Station, 1958 (detail)
magna on canvas
77 7/8 x 60 1/2 in.
(197.8 x 153.7 cm)
National Gallery of Art, Washington D.C.,
Robert and Jane Meyerhoff Collection

Giotto di Bondone (1266-1336)
The Meeting of Joachim and Anna at the Golden Gate, 1305 (detail)
fresco
72 3/4 x 78 3/4 inches
(185 x 200 cm)
Scrovegni Chapel, Padua, Italy

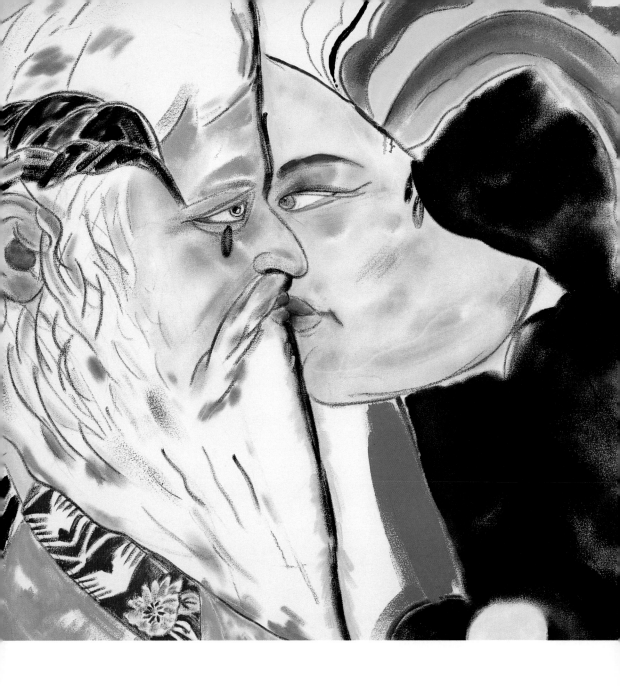

LOS ANGELES NO.17, 2002
oil on canvas
36 x 36 inches
(91.4 x 91.4 cm)

15

R.B. Kitaj

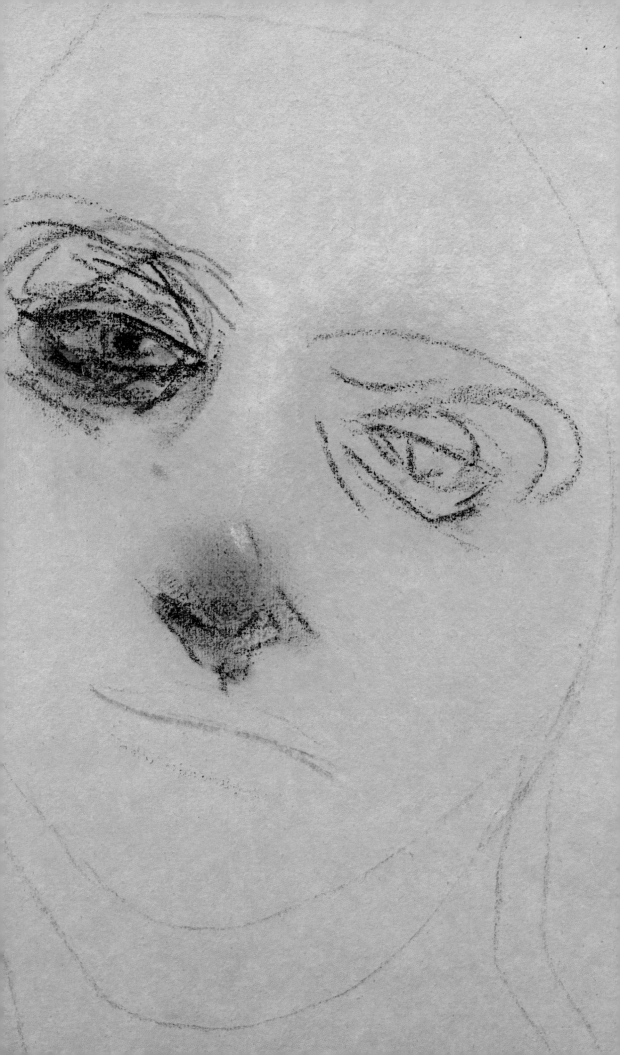

The title tells almost all. The largely erased face is a
montage of two Jewish Heroine Martyrs: Sandra and
Michelangelo's Virgin.

THREE ABSTRACTS UNERASED, 2000 – 2003
pastel and charcoal on paper with oil
22 ¾ x 15 ¼ inches
(57.8 x 38.7 cm)

R.B. Kitaj

LOS ANGELES NO.6, 2001
oil on canvas
48 x 48 inches
(122 x 122 cm)

This composition is based on very old Titian's last picture, the *Pietà*, finished by Palma, in the Accademia at Venice. In my painting, shown here in Venice, CA, Sandra is in the pose of the Christ, I am the angel merging with her from above, and Moses looms up on the left. Three Jews. Four if you count Christ.

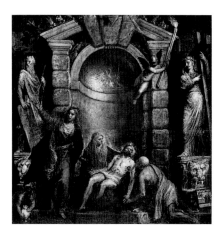

Titian (Tiziano Vecelli, c. 1488-1576)
Pietà, c.1576
139 x 137 inches
(353 x 348 cm)
Accademia di Bella Arti, Venice, Italy

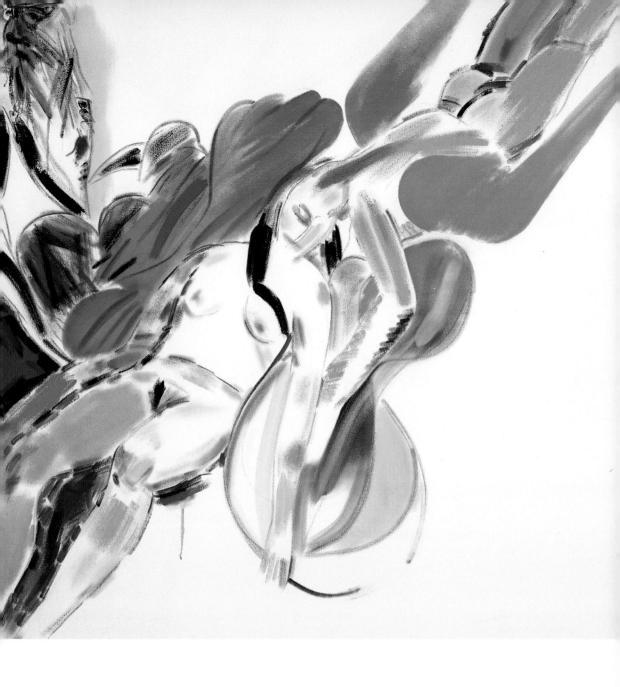

19

After 2 billion abstractions have been painted, I thought maybe I would try too. I prefer to call mine Jewish, which may or may not distinguish them from the 2 billion. I make one every year or two. This one is a rough and ready version of the upper right-hand corner of a Matisse painting of 1914 called *Goldfish and Palette*, in the Mr. and Mrs. Samuel Marx collection. I painted it because Clement Greenberg wrote that the picture is very great except for this "unresolved fault", which seemed to me gloriously talmudic. In fact you could call it a Jewish joke.

MY FOURTH JEWISH ABSTRACT, 2002 – 2003
oil and charcoal on canvas
12 x 12 inches
(30.5 x 30.5 cm)

R.B. Kitaj

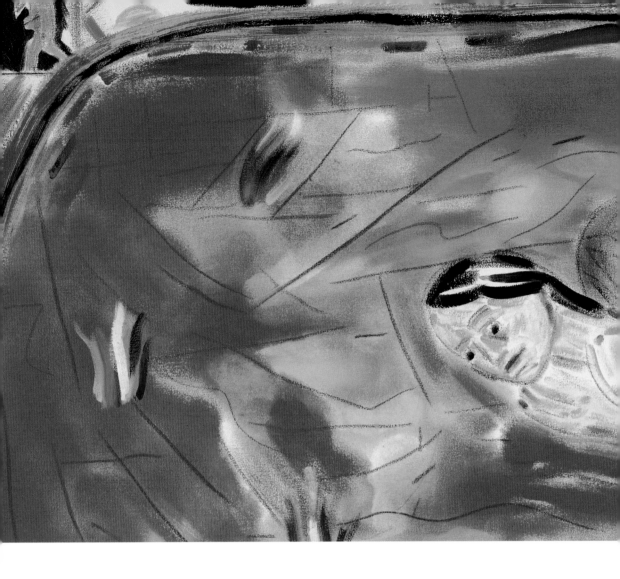

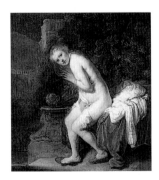

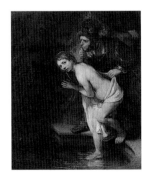

The two angels were drawn from two Rembrandt
Susannas of the Bible story, one at The Hague
and the other in Berlin. The pool is seen from
my studio in L.A., at my house called Westwest.
The water is red because Sandra still lives with
me in Los Angeles and the sap of life is red.

Rembrandt Harmensz van Rijn (1606-1669)
Susanna, c. 1636
oil on panel
18½ x 15¼ in.
(47.2 x 38.6 cm)
Royal Cabinet of Paintings, Mauritshuis,
The Hauge, Holland

Rembrandt Harmensz van Rijn (1606-1669)
Susanna Surprised by the Elders, c. 1647 (detail)
oil on mahogany
30¼ x 36½ in.
(76.6 x 92.7 cm)
Staatliche Museen zu Berlin, Gemäldegalerie

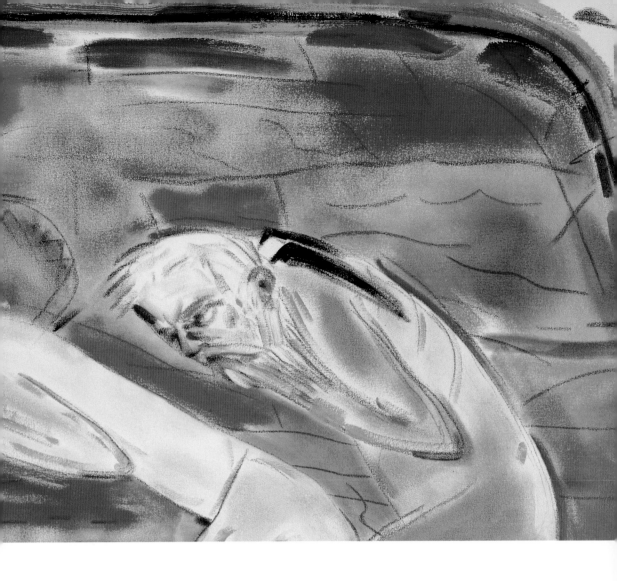

LOS ANGELES NO. 10, 2002 – 2003
oil on canvas
24 x 60 inches
(61 x 152.4 cm)

R.B. Kitaj

CROUCH DANCE (SELF PORTRAIT), 2001 – 2003
charcoal on paper
30 ½ x 22 ½ inches
(77.5 x 57.2 cm)

This Self-Portrait is formed and informed by a movie still of
W.C. Fields in a crouch at a keyhole, which is one of about 25
tiny images which I've kept for 30 years or more in a sort of
repertory company composed of human forms, many from
past art, which continue to strike and excite me in what Aby
Warburg called the Social Memory... my memory. They feed
my Life of Forms.

Los Angeles Pictures

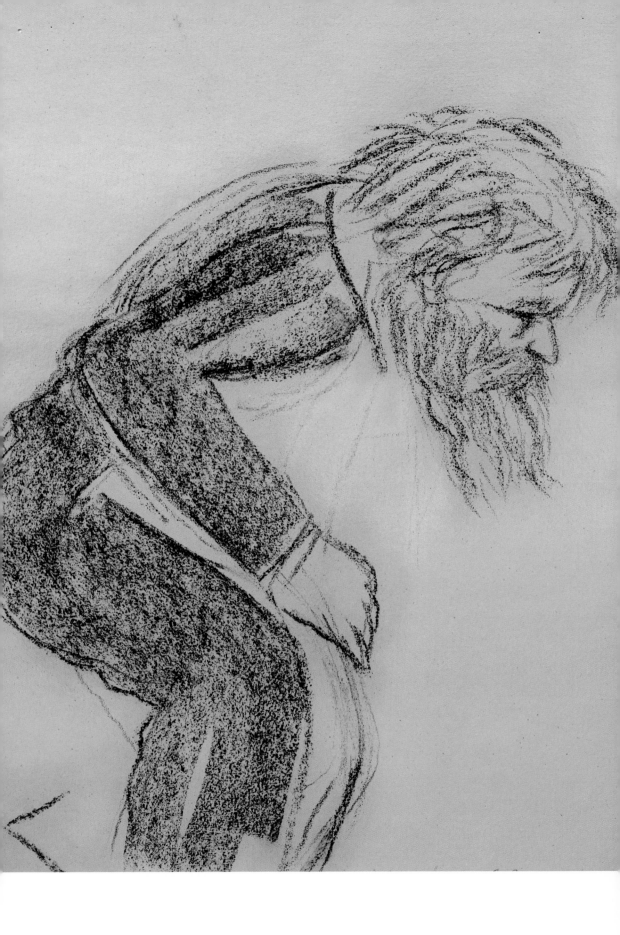

25

UCLA FILM DEPT., 2001 – 2003
charcoal on paper
30 ½ x 22 ½ inches
(77.5 x 57.2 cm)

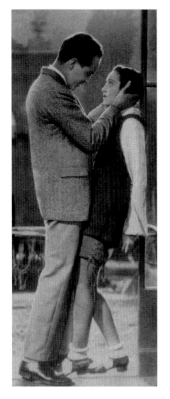

Based on a still from the movie, *The Violinist of Florence*,
starring the famous Jewish actress Elisabeth Bergner
and directed by her Jewish husband Paul Czinner. I live
one block from UCLA and my streets and café are teeming
with UCLA girls. 33 years ago, I taught there for a year and
freely dated students. Now I'm way too old and I'm told it's
not allowed anyway. So this is an old man's Self-Portrait
with a UCLA student the old man has almost forgotten
what to do with.

Film still from *The Violinist of Florence* (Der Geiger von Florenz)
1926, Germany, Director: Paul Czinner

Los Angeles Pictures

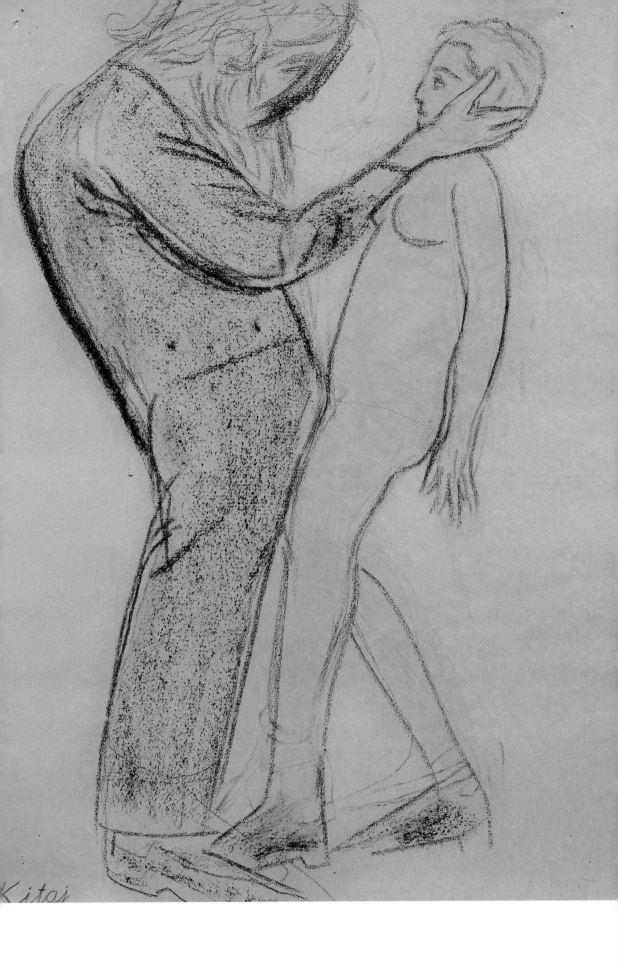

Kitaj

R.B. Kitaj

LOS ANGELES NO.12, 2002
oil on canvas
30 x 40 inches
(76.2 x 101.6 cm)

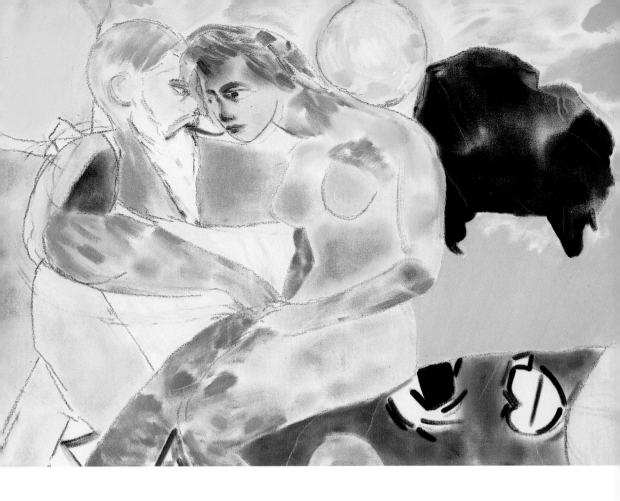

R.B. Kitaj

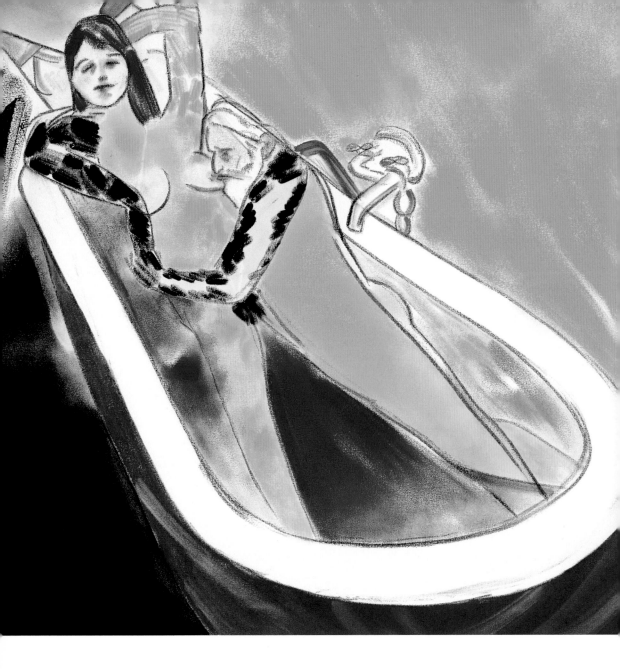

LOS ANGELES NO.11, 2002 – 2003
oil on canvas
36 x 36 inches
(91.4 x 91.4 cm)

R.B. Kitaj

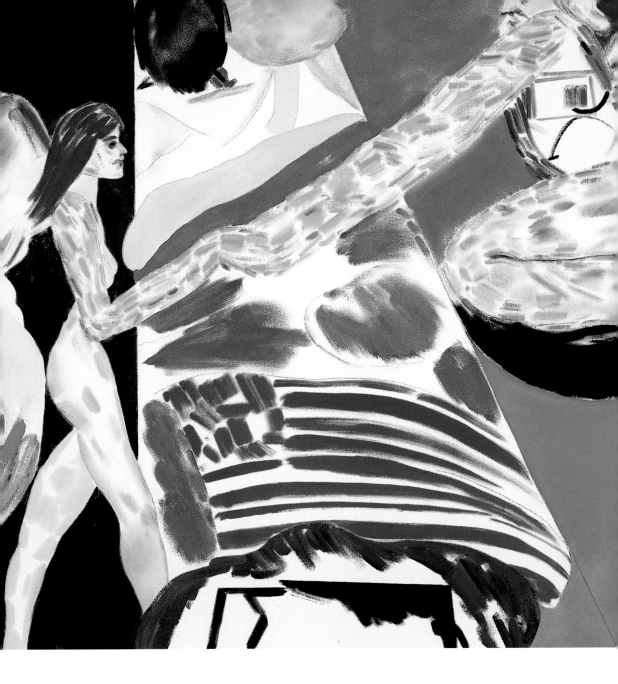

LOS ANGELES NO.16, 2001 – 2002
oil on canvas
48 x 48 inches
(122 x 122 cm)

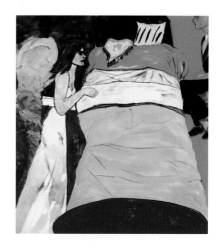

This painting is a sequel to an amazingly prophetic
picture of mine painted 20 years ago called *I Married
An Angel* (named after the Rodgers and Hart musical).
Of course, the arms bonding Sandra and me are more
of a stretch now in Los Angeles.

R.B. Kitaj
I Married An Angel, 1990
oil on canvas
48 x 47 ⅞ inches
(121.9 x 121.6 cm)
Private Collection

GOD'S BACK, 1997 – 2000
pastel and charcoal on paper
30 ½ x 22 ½ inches
(77.5 x 57.2 cm)

"Thou canst see My back, but My face shall not be seen... for
man shall not see Me and live." (Exodus 33:20-21). Not many
people know that Moses actually saw God's Back! That leaves
me free to imagine (and re-imagine) what Moses saw. I wonder
if any painter ever tried that?

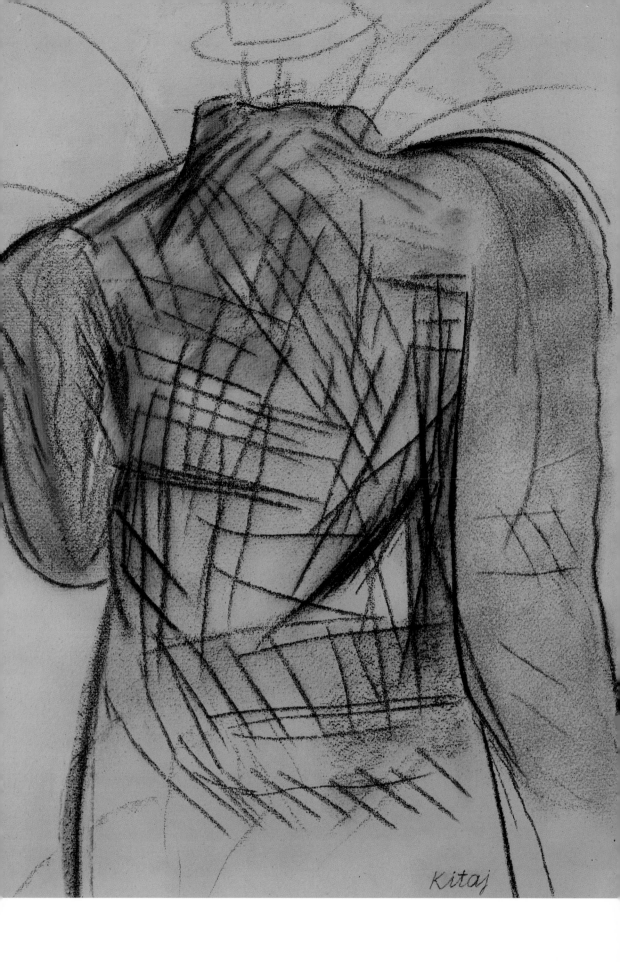

35

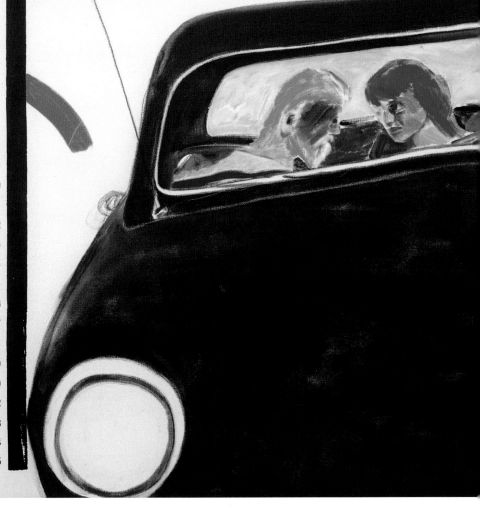

abstraction
création
art non
figuratif 1932

LOS ANGELES NO.9, 1969 – 2002
oil on canvas
60 x 47 ½ inches
(152.4 x 120.7 cm)

In the sixties, I made this silkscreen canvas in London
and forgot about it for 35 years. When I unpacked it in L.A.
I saw that the lower right quarter was blank and I could
paint in there, so I did. I painted a version of the black
car famously photographed by Robert Frank, with Sandra
(hair dyed red) and me, The Angels, in conversation in
the car. Abstraction-Creation was an avant-garde group of
abstractionists in Paris and this issue of their magazine was
published in 1932, the year of my birth. I've re-issued it 70
years later in Los Angeles in my 70th year.

R.B. Kitaj

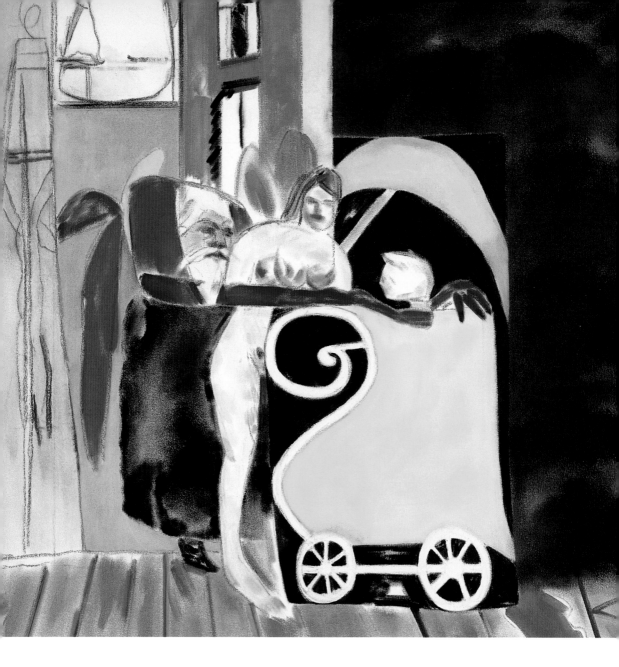

LOS ANGELES NO.13, 2002
oil on canvas
36 x 36 inches
(91.4 x 91.4 cm)

My picture reproduces a musical number by Moyshe Broderson in Lodz,
Poland, in 1927. Of course the actors were probably murdered ten years later
(see the chimney on the left of my painting). Sandra and I are pictured in Los
Angeles with our Max in his pram. But he's grown up now in L.A. in peace.

Szymon Dzigan and Shmulik Goldstein in a satirical
revue presented at the Ararat *kleynkunst* theater in
1927, Lodz, Poland.

R.B. Kitaj

LOS ANGELES NO.15, 2002
oil on canvas
48 x 48 inches
(122 x 122 cm)

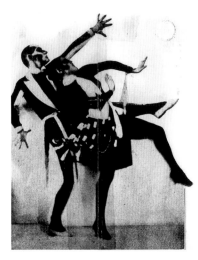

My source for the angels of Sandra and me is from Avrom
Goldfadn's 1926 Yiddish Theater production *The Tenth
Commandment*, which is significant because the drama took
place on heaven and earth. The Black Sun of (California?)
melancholy looms over us because it was painted in L.A.

Twin Dancers in *The Dance to Hell* from Alexander Granovsky's
The Tenth Commandment, 1920s, USSR

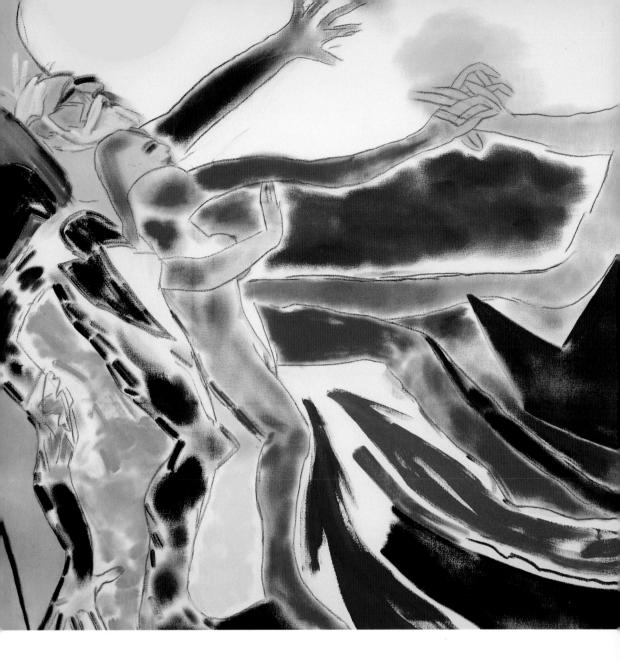

41

SELF PORTRAIT (AFTER WEEGEE), 2000 – 2003
charcoal and pastel on paper with oil
22 ½ x 30½ inches
(57.2 x 77.5 cm)

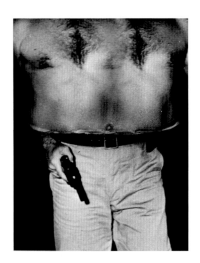

Weegee (Arthur Fellig, 1899-1968)
Villain, ca. 1950
Gelatin silver print
9½ x 7⅜ inches
(24.1 x 18.7 cm)
International Center of Photography, New York

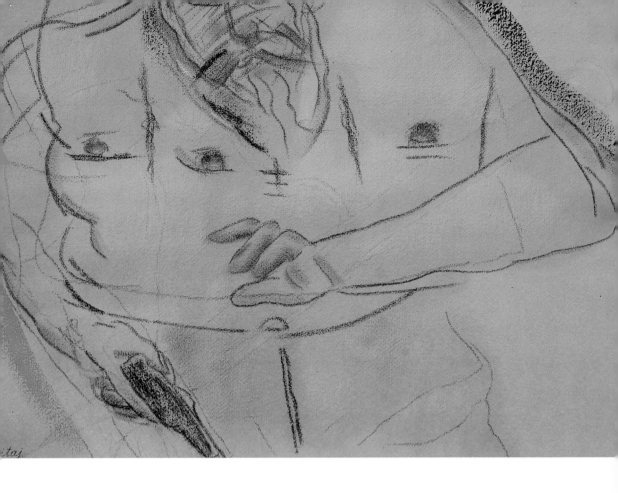

R.B. Kitaj

BUCKET RIDER, 2002 – 2003
pastel and charcoal on paper
30 ½ x 22 5/8 inches
(77.5 x 57.5 cm)

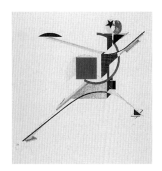

In Kafka's short story, the *Bucket Rider* can't afford to buy coal, so he flies over the city toward the far north. It took me a long while to find a Jewish Rider, but I found one in El Lissitzky's *New Man*, 1923.

El Lissitzky (1890-1941)
New Man from Victory over the Sun (Sieg uber die Sonne), 1923
color lithograph
15 x 10 1/2 in.
(38.1 x 26.7 cm)
Philadelphia Museum of Art

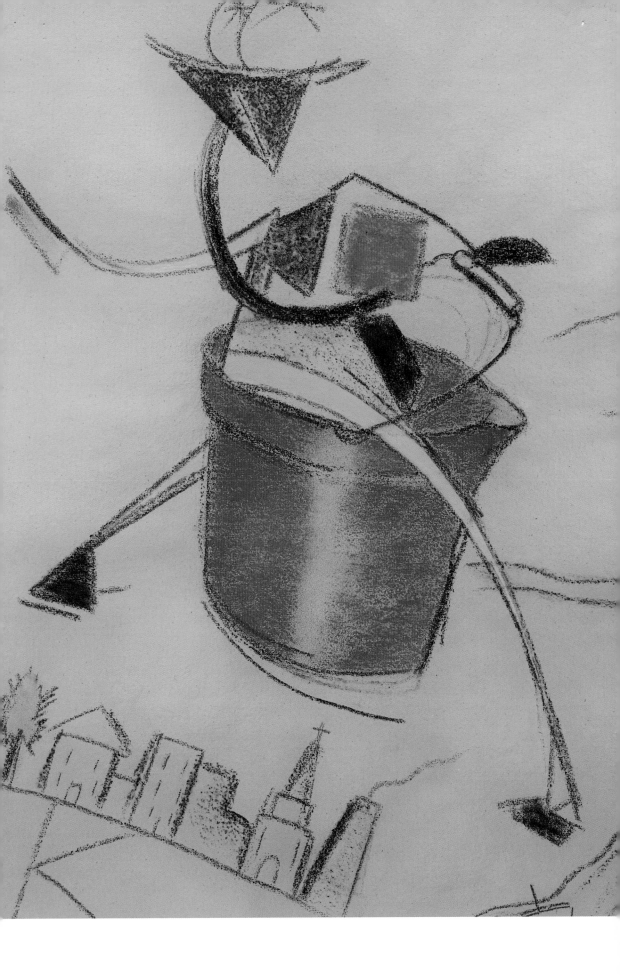

45

R.B. Kitaj

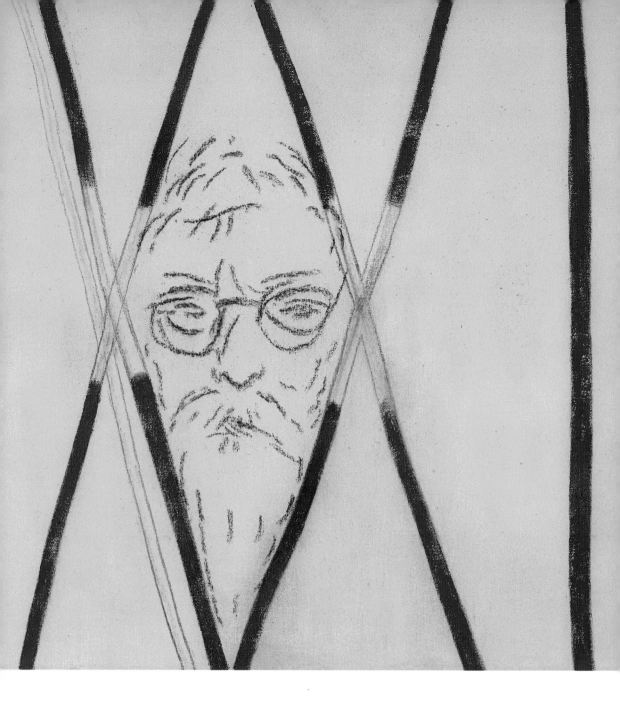

46

XXI SELF PORTRAIT, 2002 – 2003
oil on canvas
24 x 24 inches
(61 x 61 cm)

R.B. Kitaj

SELF PORTRAIT AS A MONDRIAN, 2001 – 2003
oil on canvas
12 x 12 inches
(30.5 x 30.5 cm)

49

R.B. Kitaj

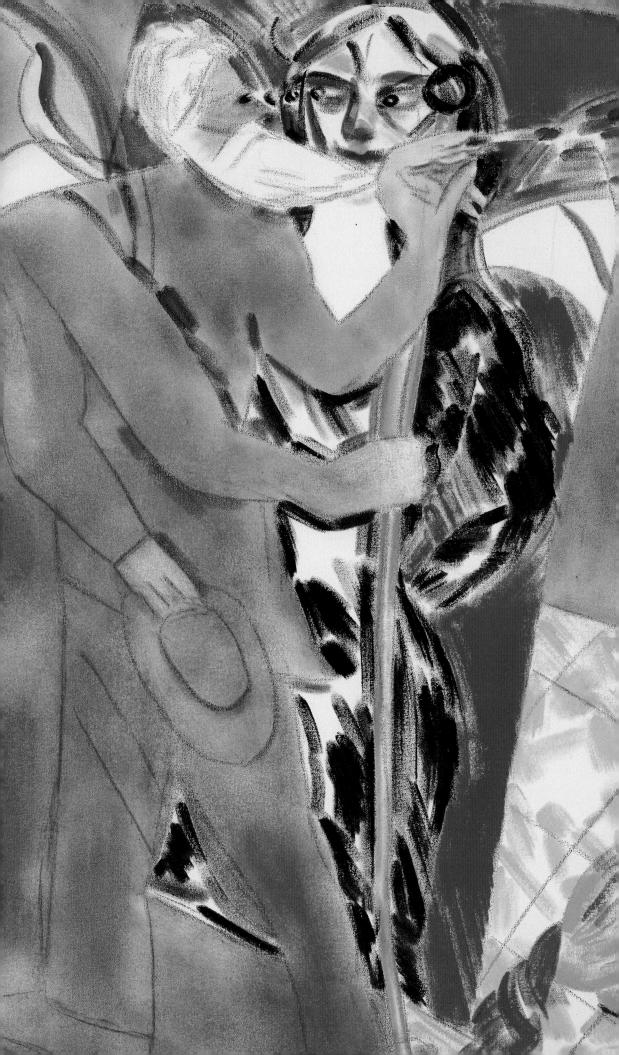

I've fashioned myself here after old illustrations of Ahasuerus, The Wandering Jew. In my painting, I'm using The Jew's staff as a mahlstick to paint wings on the last portrait I painted of Sandra before she died in London, which now pervades my L.A. studio and influences my pictures.

LOS ANGELES NO.8, 2002
oil on canvas
36 x 21 ½ inches
(91.4 x 57.2 cm)

R.B. Kitaj

LOS ANGELES NO. 4, 2000 – 2001
oil on canvas
72 x 36 inches
(182.9 x 91.4 cm)

This is a montage of Sandra and me as One, inspired by the
great, crazy, unfinished Bathers of Cézanne in the Barnes
Collection. I've used the extraordinary, de-gendered figures
on the extreme right and extreme left (the so-called penis-
head) which Cézanne painted just before he died in 1906.

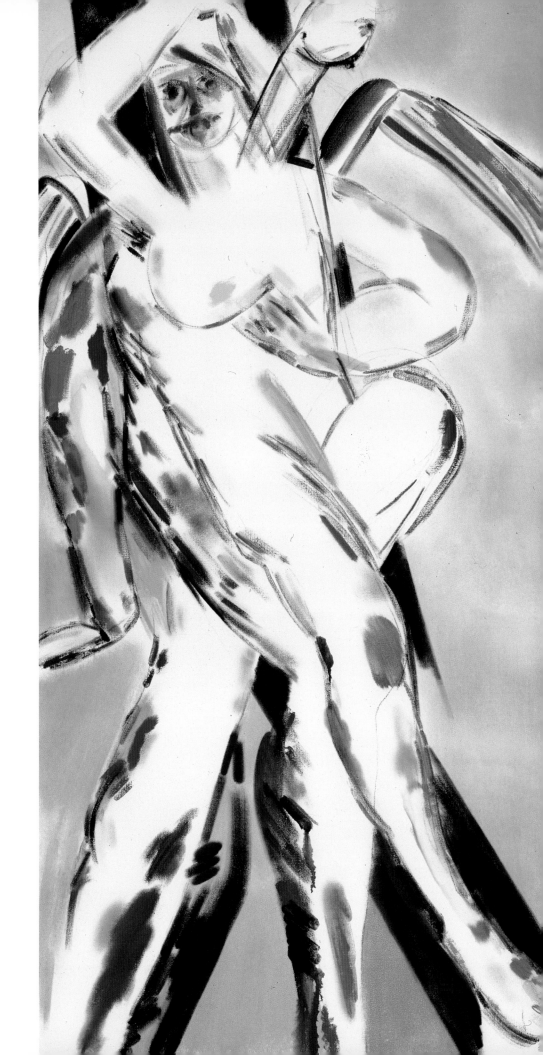

LOS ANGELES NO. 7, 2001
oil on canvas
36 x 36 inches
(91.4 x 91.4 cm)

Sandra and me, based on a single, small Cézanne Bather.

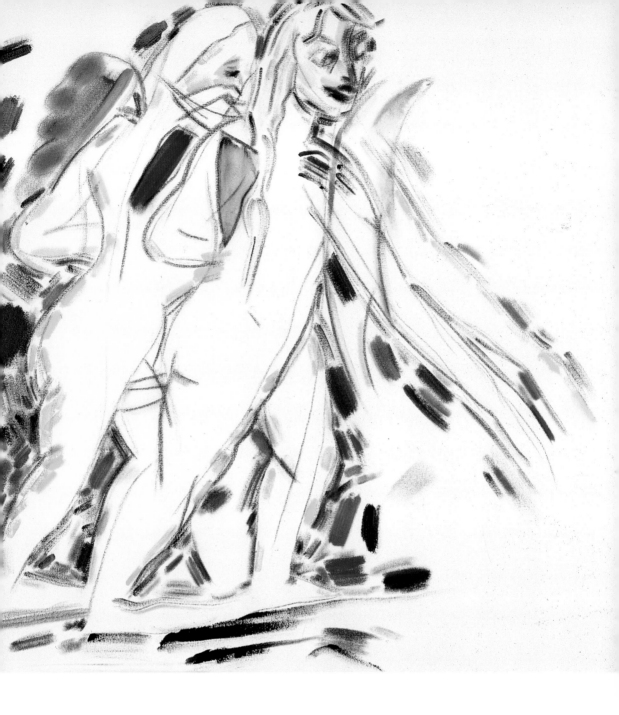

55

R.B. Kitaj

LOS ANGELES NO.21, 2003
oil on canvas
36 x 36 inches
(91.4 x 91.4 cm)

Self-Portrait with Sandra. She never grew old, but I
grow older and older. I began this picture age 70, so
I dyed my hair crimson and my beard turquoise.

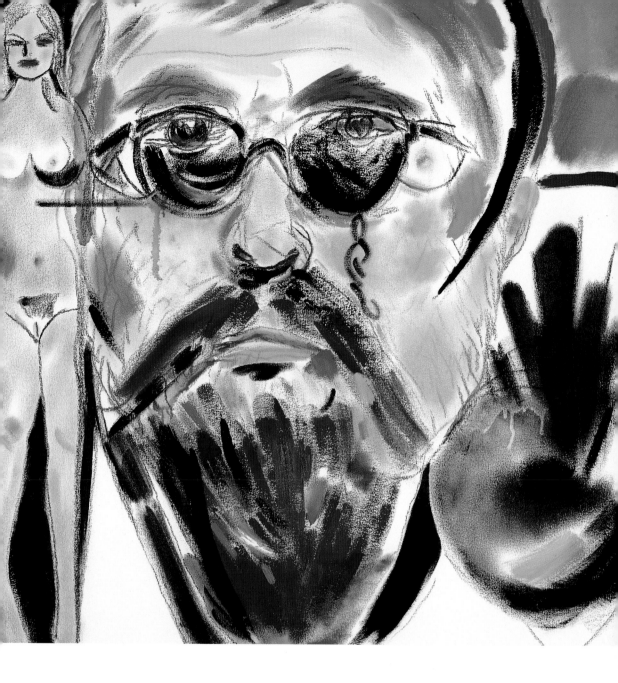

R.B. Kitaj

EMILY DICKINSON, 2000 – 2003
pastel and charcoal on paper with oil
22 x 15 ¼ inches
(55.9 x 38.7 cm)

I've been drawing poets all my life, mostly from life.
Sandra's E.D. book lies by my easel in L.A. This drawing
is based, of course, on the only known photo of Miss Em.

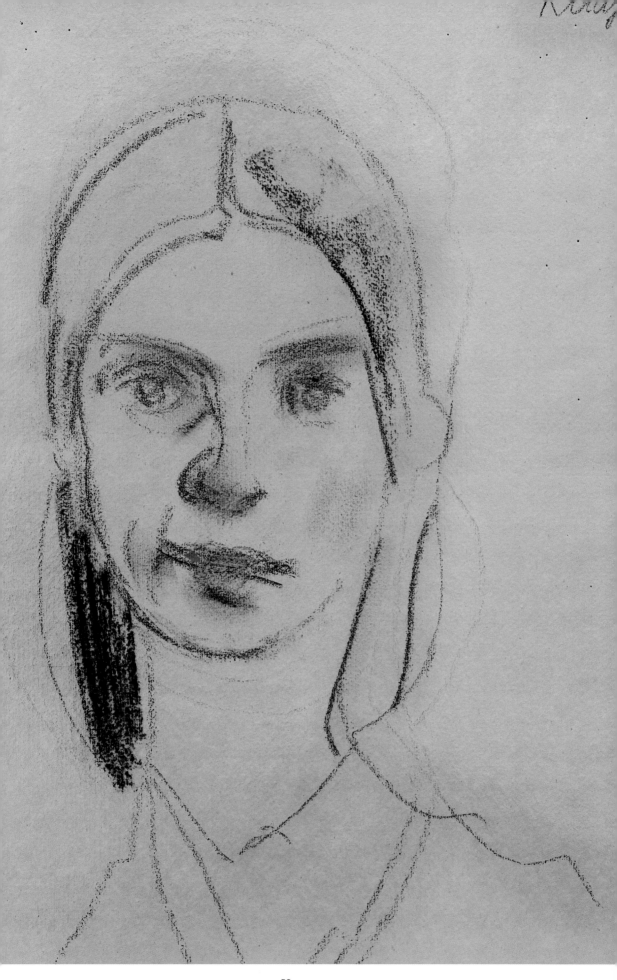

59

PROUST, 2001 – 2003
pastel and charcoal on paper with oil
30 ½ x 22 ¼ inches
(77.5 x 56.5 cm)

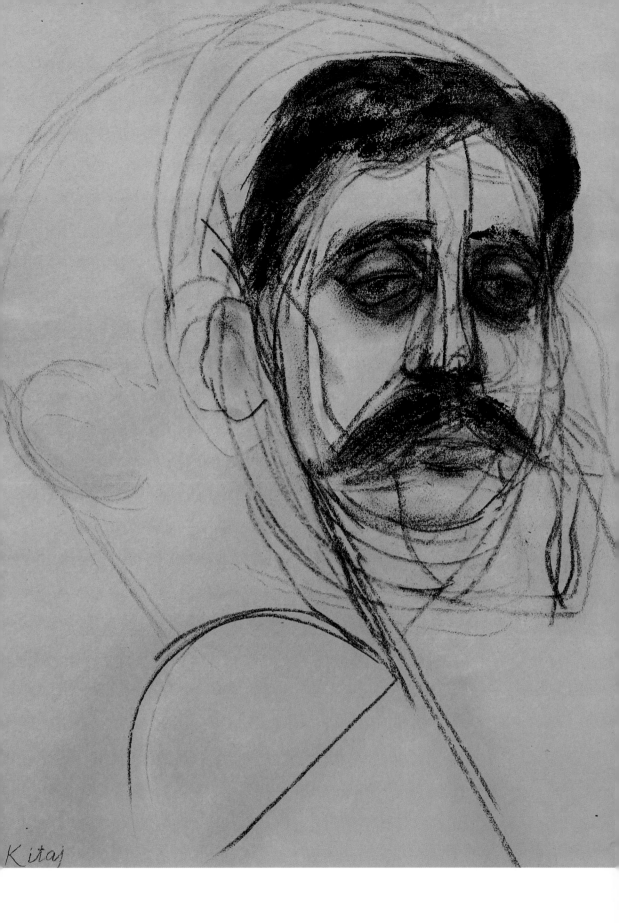

Kitaj

R.B. Kitaj

AFTER A SELF PORTRAIT BY PISSARRO, 2000 – 2003
pastel and charcoal on paper with oil
30 ½ x 22¼ inches
(77.5 x 56.5 cm)

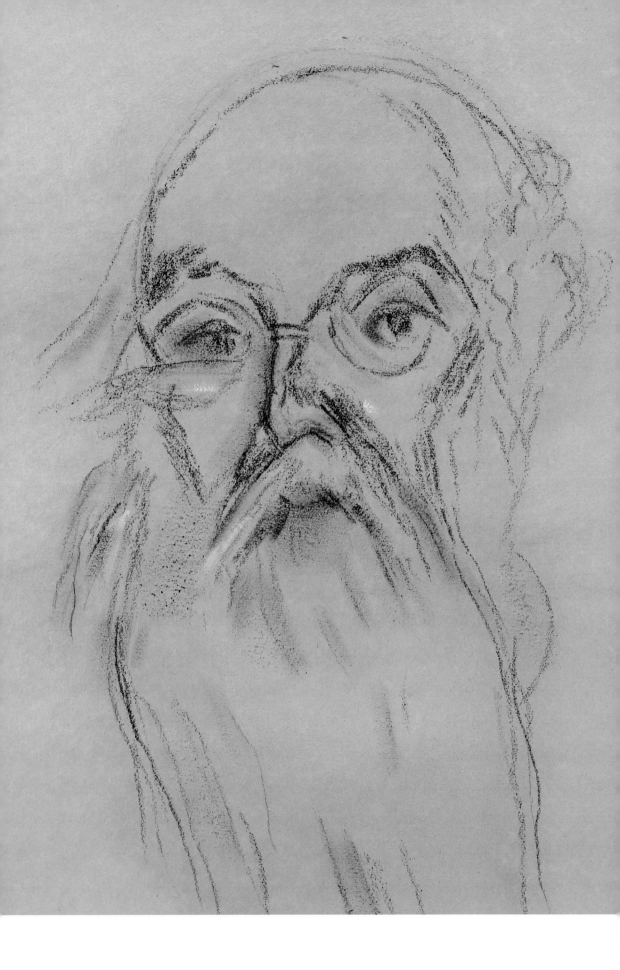

63

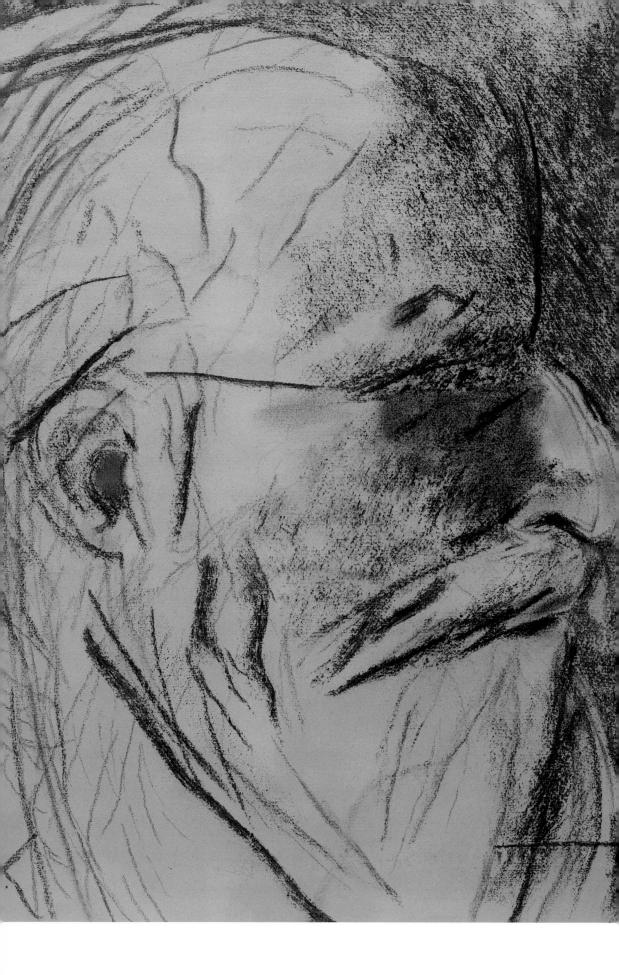

SELF PORTRAIT 2003, 2002 – 2003
charcoal on paper
30 ½ x 22 ½ inches
(77.5 x 57.2 cm)

R.B. Kitaj

YOUNG MONDRIAN (AFTER HIS SELF PORTRAIT), 2001 – 2003
pastel and charcoal on paper with oil
22 ¼ x 15¼ inches
(56.5 x 38.7 cm)

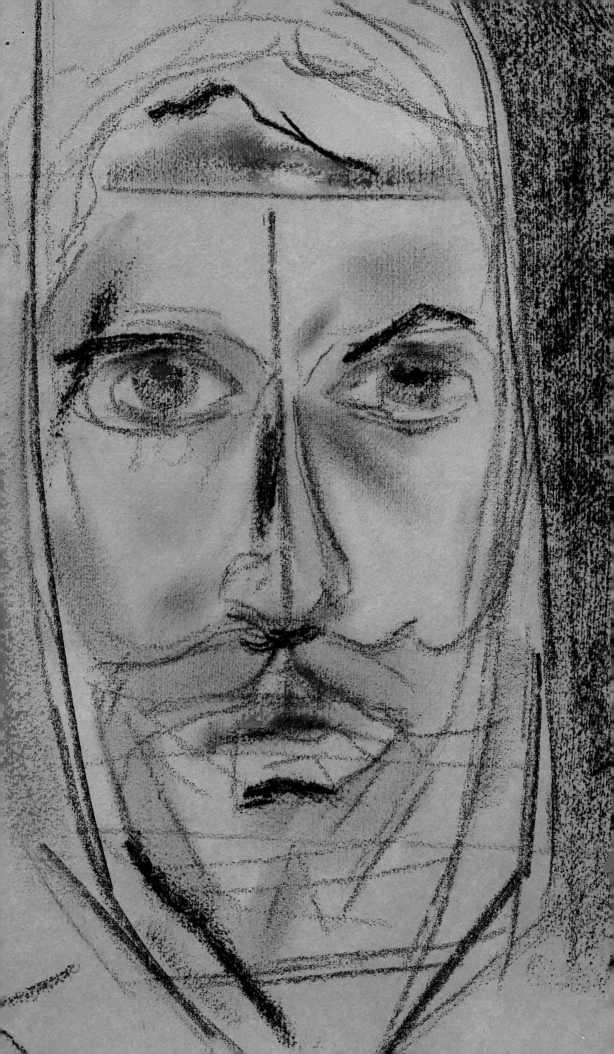

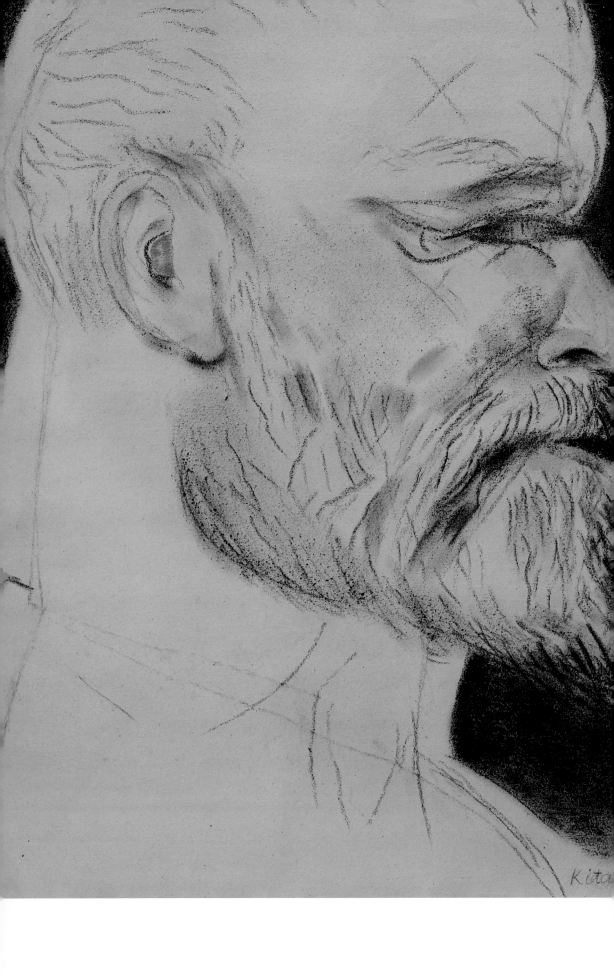

68

SELF PORTRAIT WITH RED HEARING AID, 1997-2001
pastel on paper
30 ½ x 22 ½ inches
(77.5 x 57.2 cm)

R.B. Kitaj

LOS ANGELES NO.20, 1990 – 2003
oil on canvas
60 x 60 ¼ inches
(152.4 x 153 cm)

Who Can Be Happy and Free? was painted 20 years ago. When it arrived at Westwest, my house in L.A., I turned it into LOS ANGELES NO.20. The original composition was inspired by Rembrandt's *Joseph and Potiphar's Wife*, the bible story (National Gallery, Washington, D.C.). In LOS ANGELES NO.20, I'm trying to get Sandra back from Mr. Death, the Angel of Death. Many Jewish folk-customs are designed to ward him off.

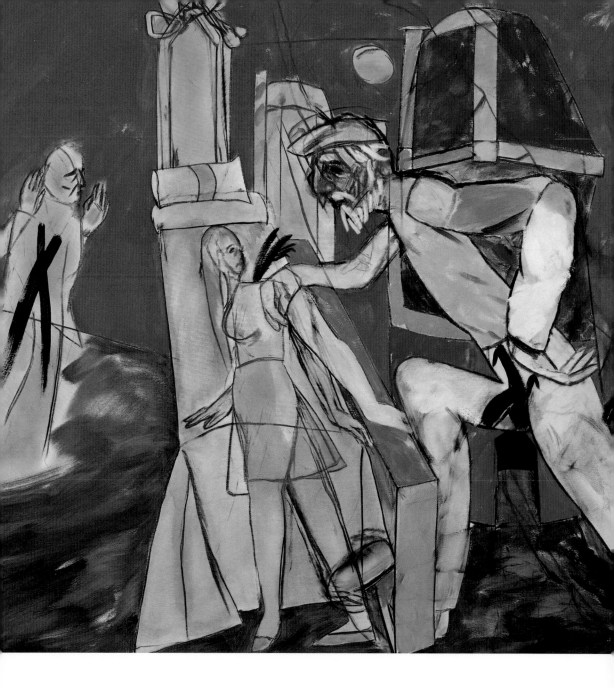

71

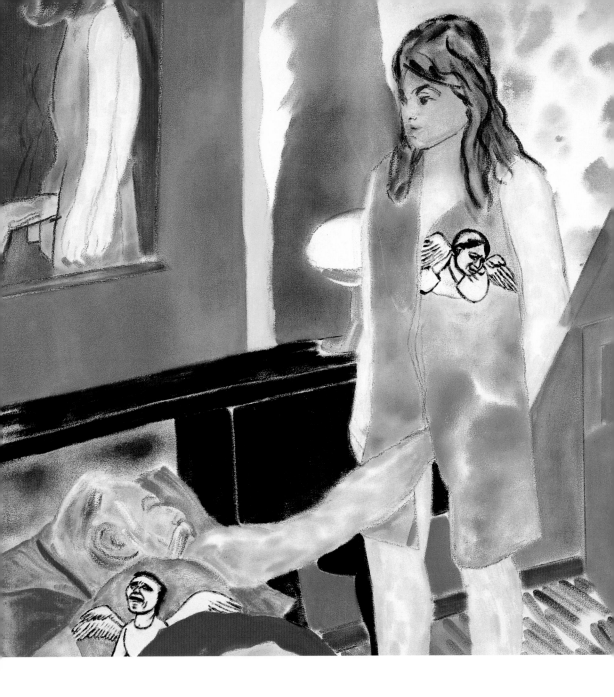

LOS ANGELES NO.18; 2002
oil on canvas
36 x 36 inches
(91.4 x 91.4 cm)

R.B. Kitaj

LOS ANGELES NO.19, 2003
oil on canvas
36 x 36 inches
(91.4 x 91.4 cm)

On which (unfinished) master painting is this picture based?
You guess. My picture shows Sandra and me in front of my
yellow studio by the pool at Westwest. The Fox tower was
suggested by the one on the deco movie theater just down
my street in Westwood Village.

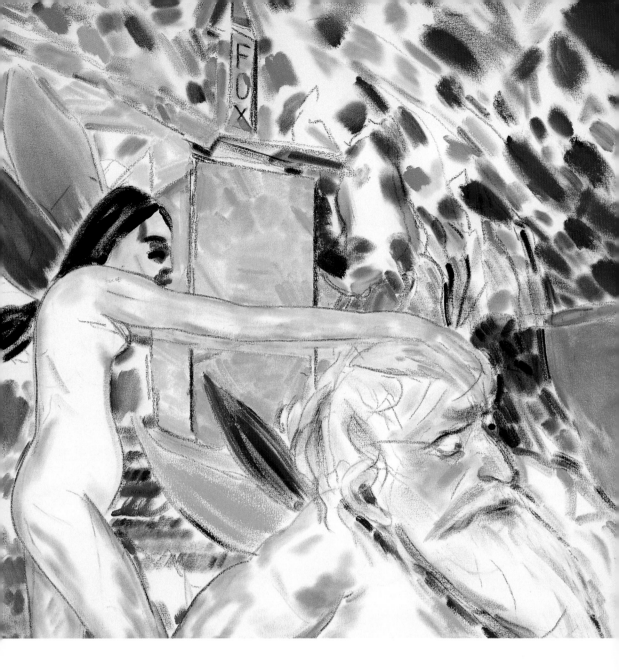

75

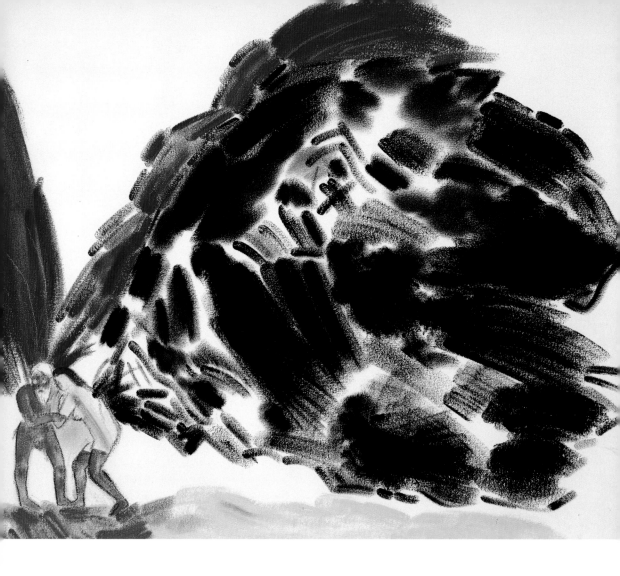

Los Angeles Pictures

LOS ANGELES NO.14, 2002 – 2003
oil on canvas
20 1/8 x 24 1/8 inches
(50.8 x 60.9 cm)

R.B. Kitaj

LOS ANGELES NO.22, 2001
oil on canvas
36 x 36 inches
(91.4 x 91.4 cm)

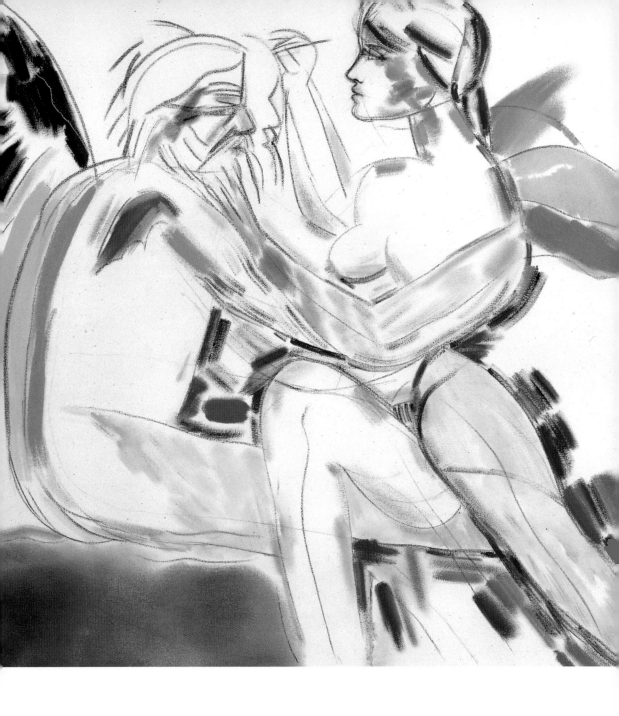

R.B. Kitaj

LOS ANGELES PICTURES

LOS ANGELES NO.17, 2002
oil on canvas
36 x 36 inches
(91.4 x 91.4 cm)

THREE ABSTRACTS UNERASED,
2000 – 2003
pastel and charcoal on paper with oil
22 3/4 x 15 1/4 inches
(57.8 x 38.7 cm)

LOS ANGELES NO.6, 2001
oil on canvas
48 x 48 inches
(122 x 122 cm)

MY FOURTH JEWISH ABSTRACT,
2002 – 2003
oil and charcoal on canvas
12 x 12 inches
(30.5 x 30.5 cm)

LOS ANGELES NO.10, 2002 – 2003
oil on canvas
24 x 60 inches
(61 x 152.4 cm)

CROUCH DANCE (SELF PORTRAIT),
2001 – 2003
charcoal on paper
30 1/2 x 22 1/2 inches
(77.5 x 57.2 cm)

UCLA FILM DEPT., 2001 – 2003
charcoal on paper
30 1/2 x 22 1/2 inches
(77.5 x 57.2 cm)

LOS ANGELES NO.12, 2002
oil on canvas
30 x 40 inches
(76.2 x 101.6 cm)

LOS ANGELES NO.11, 2002 – 2003
oil on canvas
36 x 36 inches
(91.4 x 91.4 cm)

LOS ANGELES NO.16, 2001 – 2002
oil on canvas
48 x 48 inches
(122 x 122 cm)

GOD'S BACK, 1997 – 2000
pastel and charcoal on paper
30 1/2 x 22 1/2 inches
(77.5 x 57.2 cm)

LOS ANGELES NO.9, 1969 – 2002
oil on canvas
60 x 47 1/2 inches
(152.4 x 120.7 cm)

LOS ANGELES NO.13, 2002
oil on canvas
36 x 36 inches
(91.4 x 91.4 cm)

LOS ANGELES NO.15, 2002
oil on canvas
48 x 48 inches
(122 x 122 cm)

SELF PORTRAIT (AFTER WEEGEE),
2000 – 2003
charcoal and pastel on paper with oil
22 1/2 x 30 1/2 inches
(57.2 x 77.5 cm)

BUCKET RIDER, 2002 – 2003
pastel and charcoal on paper
30 1/2 x 22 5/8 inches
(77.5 x 57.5 cm)

XXI SELF PORTRAIT, 2002 – 2003
oil on canvas
24 x 24 inches
(61 x 61 cm)

SELF PORTRAIT AS A MONDRIAN,
2001 – 2003
oil on canvas
12 x 12 inches
(30.5 x 30.5 cm)

LOS ANGELES NO.8, 2002
oil on canvas
36 x 21 1/2 inches
(91.4 x 57.2 cm)

LOS ANGELES NO.4, 2000 – 2001
oil on canvas
72 x 36 inches
(182.9 x 91.4 cm)

LOS ANGELES NO.7, 2001
oil on canvas
36 x 36 inches
(91.4 x 91.4 cm)

LOS ANGELES NO.21, 2003
oil on canvas
36 x 36 inches
(91.4 x 91.4 cm)

EMILY DICKINSON, 2000 – 2003
pastel and charcoal on paper with oil
22 x 15 1/4 inches
(55.9 x 38.7 cm)

PROUST, 2001 – 2003
pastel and charcoal on paper with oil
30 1/2 x 22 1/4 inches
(77.5 x 56.5 cm)

AFTER A SELF PORTRAIT BY
PISSARRO, 2000-2003
pastel and charcoal on paper with oil
30 1/2 x 22 1/4 inches
(77.5 x 56.5 cm)

SELF PORTRAIT 2003, 2002 – 2003
charcoal on paper
30 1/2 x 22 1/2 inches
(77.5 x 57.2 cm)

YOUNG MONDRIAN (AFTER HIS
SELF PORTRAIT), 2001 – 2003
pastel and charcoal on paper with oil
22 1/4 x 15 1/4 inches
(56.5 x 38.7 cm)

SELF PORTRAIT WITH RED HEARING
AID, 1997-2001
pastel on paper
30 1/2 x 22 1/2 inches
(77.5 x 57.2 cm)

LOS ANGELES NO.20, 1990 – 2003
oil on canvas
60 x 60 1/4 inches
(152.4 x 153 cm)

LOS ANGELES NO.18, 2002
oil on canvas
36 x 36 inches
(91.4 x 91.4 cm)

LOS ANGELES NO.19, 2003
oil on canvas
36 x 36 inches
(91.4 x 91.4 cm)

LOS ANGELES NO.14, 2002-2003
oil on canvas
20 1/8 x 24 1/8 inches
(50.8 x 60.9 cm)

LOS ANGELES NO.22, 2001
oil on canvas
36 x 36 inches
(91.4 x 91.4 cm)

BIOGRAPHY

1932	R.B. Kitaj is born as Ronald Brooks in Cleveland, Ohio
1941	Kitaj's mother, Jeanne Brooks, the daughter of Russian Jews, marries for the second time. Her husband is Dr. Walter Kitaj, a Viennese Jew.
1949	First sailing as a merchant seaman
1950-51	Cooper Union Institute, New York
1951	Further travels as a seaman
	Studies at the Academy of Fine Art, Vienna
1956-58	U.S. Army of Occupation, AFCE HQ (Armed Forces Central Europe)
1957-59	Ruskin School of Drawing, University of Oxford, where he attended lectures by Edgar Wind and Douglas Cooper
1959-61	Royal College of Art, London
	Forms lasting friendship with David Hockney
1962-65	Settles in London and teaches at Camberwell and the Slade
1970-71	Teaches at UCLA. Meets Sandra Fisher
1976	Curates the polemical exhibition *The Human Clay* at the Hayward Gallery London and coins the loose term The School of London, to describe the various London-based artists devoted to representations of the figure.
1980	Selects *The Artist's Eye* exhibition at the National Gallery, London
1983	Marries his second wife, American artist Sandra Fisher
1989	Publishes *First Diasporist Manifesto*, translated into German and Hungarian
1994	Major retrospective at the Tate Gallery London. Hostile and personal attacks from some critics spark what Kitaj has called the 'Tate War'. Sudden death of Sandra Fisher at the age of 47.
1994-95	The retrospective exhibition is shown at the Metropolitan Museum of Art, New York and the Los Angeles County Museum of Art.
1985-95	Five Honorary Doctorates
1995	Wins the Golden Lion at Venice Biennale
1996	Chevalier in Order of Arts and Letters, Paris
1997	Following the death of his wife and feeling that London was also now dead for him, Kitaj returns to live in the USA, with Max, his young son by Sandra. They settle in Los Angeles among sons and grandsons.
1999	Exhibition at the National Gallery, London: *Kitaj In The Aura Of Cézanne And Other Masters*
2001	Begins to write his Confessions, *How To Reach x Years In Jewish Art*

PUBLIC COLLECTIONS

Albright-Knox Art Gallery, Buffalo, New York
Akron Art Museum, Akron, Ohio
Arkansas Art Center, Little Rock, Arkansas
Arts Council of England, London, England
Ashmolean Museum of Art and Archaeology, Oxford, England
Astrup Fearnley Museet for Moderne Kunst, Oslo, Norway
Baltimore Museum of Art, Baltimore, Maryland
British Council, London, England
British Museum, London, England
Centre National d'Art et de Culture Georges Pompidou, Paris, France
Cincinnati Art Museum, Cincinnati, Ohio
Cleveland Museum of Art, Cleveland, Ohio
Collection Thyssen-Bornemisza, Madrid, Spain
Detroit Historical Museum, Detroit, Michigan
Fondation du Judaisme Française, Paris, France
Graves Art Gallery, Sheffield, England
Hags Gemeentemuseum, The Hague, Netherlands
Hamburger Kunsthalle, Hamburg, Germany
High Museum of Art, Atlanta, Georgia
Israel Museum, Jerusalem, Israel
Kemper Museum of Contemporary Art, Kansas City, Missouri
Kunstmuseum, Düsseldorf, Germany
Laing Art Gallery, Newcastle-upon-Tyne, England
Louisiana Museum of Modern Art, Humlebaek, Denmark
Ludwig Collection, Aix-la-Chapelle, France
Metropolitan Museum of Art, New York, New York
Michael and Dorothy Blankfort Collection at Los Angeles County Museum of Art, Los Angeles, California
Museo Nacional Centro de Arte Reina Sofia, Madrid, Spain
Museum of Art, Providence, Rhode Island
Museum Bijmans van Beuningen, Rotterdam, Netherlands
Museum Ludwig, Cologne, Germany
Museum of Modern Art, New York, New York
Nasjonalgalleriet, Oslo, Norway
Nationalgalerie, Staatliche Museen zu Berlin, Germany
National Museums and Galleries of Wales, Cardiff, Wales
National Portrait Gallery, London, England
Orange County Museum of Art, Newport Beach, California
Royal Academy of Arts Gallery, London, England
Royal College of Art, London, England
Scottish National Gallery of Modern Art, Edinburgh, Scotland
Silkeborg Kunstmuseum, Silkeborg, Denmark
South African National Gallery, Cape Town, South Africa
Sprengle Museum, Hannover, Germany
Stedelijk Museum, Amsterdam, Netherlands
Stiftung Preussicher Kulturbesitz, Potsdam, Germany
Swindon Museum and Art Gallery, Swindon, England
Tate Gallery, London, England
Toledo Museum of Art, Toledo, Ohio
University College, Oxford, England
Walker Art Gallery, Liverpool, England
Whitney Museum of American Art, New York, New York
Whitworth Art Gallery, Manchester, England
Wiener Staatsoper, Vienna, Austria

PHOTOGRAPHY CREDITS

Portrait and studio photographs of R.B. Kitaj by Paul O'Connor
Kitaj works photographed by Robert Wedemeyer except for
(pp. 53, 55, 79) by Prudence Cuming Associates, courtesy
Marlborough Fine Art, London
Photo © 2003 Board of Trustees, National Gallery of Art,
Washington, D.C., p.14
Photo © Cameraphoto Arte, Venice, Italy / Art Resource, NY, p. 14
Photo © Scala / Art Resource, NY, p. 18
Photo © Royal Cabinet of Paintings, Mauritshuis,
The Hague, Holland, p. 22
Photo Jörg P. Anders © Bildarchiv Preussischer Kulturbesitz,
Staatliche Museen zu Berlin, Gemäldegalerie, 2003, p. 22
Photo © Friedrich-Wilhelm-Murnau-Stiftung; Distributor:
Transit Film GmbH, p.26
Photo © R. B. Kitaj, courtesy of Marlborough Gallery,
New York, p. 33
Photo © Courtesy of the YIVO Institute for Jewish Research
Photo Archives, p. 39 & 40
Photo © Weegee / International Center of Photography /
Getty Images, p. 42
Photo Lynn Rosenthal, 1993 © Philadelphia Museum of Art:
Gift of Dr. George J. Roth. p. 44

COLOPHON

The primary typefaces used are Filosofia and Bell Gothic. Filosofia
was designed by Zuzana Licko in 1996 and is based on the typeface,
Bodoni, designed by Giambattista Bodoni in 1768. Bell Gothic was
designed for the Bell Telephone Company's directories in 1938.

This book was designed by Sean Adams and Jennifer Hopkins
at AdamsMorioka in Los Angeles, with Peter Goulds and Liz
Fischbach at L.A.Louver. The paper used is Appleton Utopia One,
Silk. The printing and binding was completed by Insync Media.

With thanks to everyone at L.A. Louver: Trish Battistin,
Kimberly Davis, Elizabeth East, Liz Fischbach, Izabela Jadach,
Judy McInturff, Chris Pate, and Mpambo Wina.

A list of all L.A. Louver catalogues can be obtained from the gallery.

This catalogue was published by L.A. Louver on the
occasion of the exhibition, *R.B.Kitaj: Los Angeles Pictures*,
21 May – 5 July, 2003